SEASONS OF LIGHT

SEASONS OF LIGHT

PHOTOGRAPHS AND STORIES
BY PETER BROWN

POEMS AND ESSAY
BY DENISE LEVERTOV

RICE UNIVERSITY PRESS, HOUSTON

CONTENTS

Photographs and Stories by Peter Brown 1

 The Places I Took This Photograph 3

 Clothesline 7

 Time and Life 11

 Lobsters on the Road 15

 At the Races 19

 The Bogey Men of Borneo 23

 A Dog's Life 27

 A Day at the Beach 31

 Rembrandt and the South China Sea 35

 Steve Wolf Sits at the Table and Thinks 39

 Burglars 43

 Medicine Man 47

 Decisive Moments 51

 Summertime 55

 Seasons of Light 59

 Vermeer Will be 368 in the Year 2000 63

 Westminster Abbey 67

 Wimberley 71

 The Dictionary Twins in the Hebrides 75

 Around the World with John Cameron Swayze 79

 Breakfast Nativity 83

 The Confession of the Gift Horse 87

 Michelangelo and the Bull 91

 Don's House 95

 Lovers . 99

 The Bedrock of God's High School 103

 Lucky Burger 107

 The Knight's Tale 111

 Two True Stories 115

Spinoffs: Poems and Essay by Denise Levertov 119

 A Doorkey for Cordova 125

 Athanor . 127

 Window-Blind 129

 The Spy . 131

 Embrasure 133

ACKNOWLEDGMENTS

A wide variety of people have given very generously of themselves toward the publication of *Seasons of Light*. I would first like to thank Denise Levertov for her inspired contribution: her essay and five beautiful poems. Thanks also to Harrison Itz of Harris Gallery in Houston for his multifaceted support of *Seasons of Light* from portfolio to book. Without his help this publication would not have been possible. Thanks to Leo Holub for years of friendship — for his encouragement, wisdom, hand, and eye throughout the growth of this work. I want to thank Debby Satten for sharing much of her life with me, for the excitement, growth, and love that her presence generated. The assistance and encouragement of Louisa and Fayez Sarofim have been indispensable and are greatly appreciated. My thanks to the Cultural Arts Council of Houston for a grant that arrived at a crucial time, and to *American Photographer* which published three pieces in slightly altered form. Special thanks to Allen Matusow, Dean of Humanities at Rice University, and to the Department of Art and Art History at Rice; to Lorenz Eitner and the Art Department at Stanford; and to Ann Rosener, Paul Judice, Owen Wilson, Dennis Ivy, Tom James, Lew and Marcia Eatherton, and Geoff and Judy Winningham, all of whom helped early on with editing, designing, printing, or criticism. Special thanks to John McPhee for the Scottish folk tale from which "The Dictionary Twins in the Hebrides" grew.

I am also greatly indebted to Robert Adams, Jim and Harriet Baldwin, Donald Barthelme, Keith and Beth Boyle, Dick and Robin Brooks, Richard and Janet Caldwell, Bill and Ginny Camfield, Cydney Codding, Patsy Cravens, The Imogen Cunningham Trust, Jonathan Day, Marie and Steve Evnochides, Linda Finnell, Roy Flukinger, Jack and Grace Fryar, Paul Harris, Diana Hudson, Barbara Taylor and Don Hopkins, Joe Horrigan, Sally Horrigan, David and Ruth Kampmann, Julie Kohn, George Krause, Jacqueline and John Martin, Mike and Muffy McLanahan, Lynn Herbert-McLanahan, Dick and Jerry Ann Miller, Don Minnick, Joan Morganstern, Richard Nassberg, Beaumont Newhall, Melissa Noble, Bill Pannill, Kit and Ferdl Pravda, Stan and Kathy Reiser, Charles Schorre, Phyllis and Steve Segal, Jim and Syddie Sowles, Greg Spaid, Barbara Taylor, Terry Thomas, Anne Tucker, Jerry and Nancy Waller, Ned Wolf, and Steve and Lois Zamora. Thanks to all for help with this book.

I finally would like to thank my family, to whom this book is dedicated, for creating the atmosphere out of which *Seasons of Light* grew: my parents Bob and Sydney Brown, my brothers Mark and Tom, my sister Alison, and, most importantly, my wife Jill, who has been loving and supportive in ways that I had not imagined possible.

PHOTOGRAPHS AND STORIES
BY PETER BROWN

THE PLACES I TOOK THIS PHOTOGRAPH

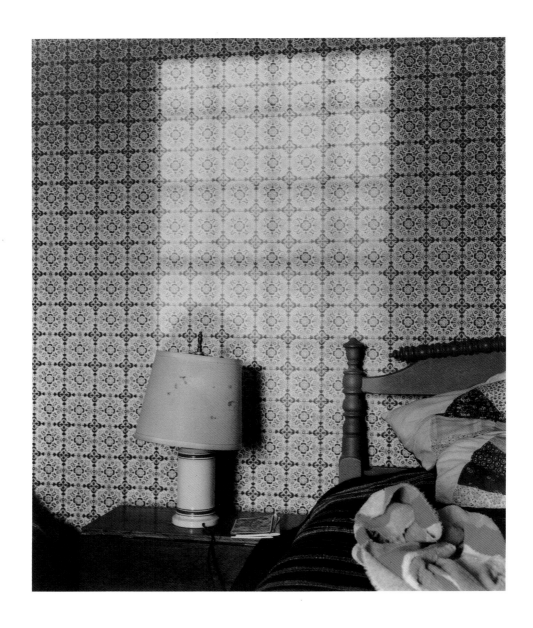

As I took this photograph for the first time, the city of Pittsburgh was burning to the ground outside. Smoke and pre-fire pollution filled the air, cars honked, people shouted, sirens howled, and, as the shutter clicked, a major American city was reduced to ashes.

The second time I took this photograph I was in Jamaica. We had just come back from the beach and the sun was setting over the water. I didn't intend to be in the picture, but for some reason I stuck my head in at the last moment. We had fished that morning and had lain on the beach all afternoon. I remember thinking as I took the photograph that the excitement of the morning did not mesh well with the boredom of the afternoon. They clunked together like Jamaica and Pittsburgh, like taking a swing and missing, like biting into a sandwich and having it disappear.

I took this photograph for the third time in northwestern Massachusetts. I was interested in the way that the light fit into the wall, the lampshade with bits and pieces of my grandmother's Chinese cutout adhering to it, the almanacs on the table; hearth, home, hominess, familiar beds, familiar rooms.

The final place I took this photograph was in Morocco. I was traveling on a summer grant which had just run out and I stumbled onto a film crew at work on a short story by Jane Bowles. I was hired for a few days to take stills. What you see here was part of an elaborate set construction that I photographed at the end of a long day of shooting.

A painter friend told me he thought it had been done in Turkey or Madagascar. This is good Pennsylvania Dutch wallpaper. Pittsburgh burns. You can make out the smokestacks in the shadows.

CLOTHESLINE

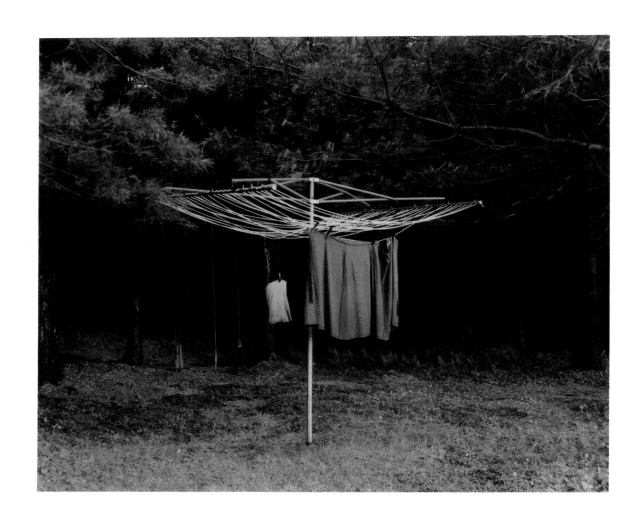

My mother has twenty-five blue skirts. Periodically they are washed and hung out on the line to dry. They all are blue and all are approximately the same size.

A small black and white calf was standing next to me as this picture was taken. It belonged to one of the children who lived on the farm down the hill and had won first prize at the fair earlier that summer. Strangely, the calf still had its worn, blue first-prize ribbon dangling from its neck.

Ten years before, the old swings in the photograph had been used daily. My brother and I had been given the job of taking care of our little brother and sister half an hour each, each morning. We would push them on the swings and take them for walks. Even in those days our mother had worn blue skirts.

At the moment the photograph was taken, nine brook trout were being kept warm on a heavy plate in the oven. I had needed to get them out and had not been able to find pot holders. My sister had said that they had been washed and put out on the line to dry. I went out and took them down. It was at that moment that the black and white calf sauntered up. I got my camera, took the photograph, and brought the pot holders back into the house to take the trout out of the oven. My mother and sister were wearing blue dresses. The calf watched through the window as we ate the trout. After we were finished we walked it down the hill to the farm. We bought fresh eggs and talked about the weather.

TIME AND LIFE

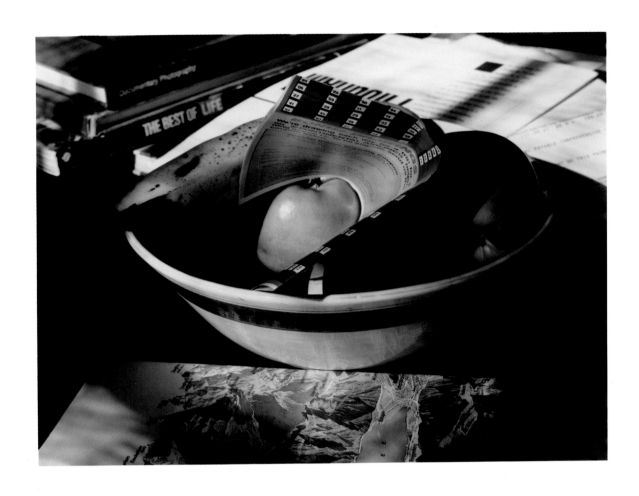

The hope in this photograph is palpable to me: newspaper contests, grant proposals, trips to Europe, *The Best of Life*, and a liquid afternoon light bathing all these possibilities, causing them to glow.

The trip to Europe, to this particular area of Switzerland outside Interlaken actually took place, but not through the scratch-the-wax bingo of the game sheet in the bowl or the grant proposal, which failed miserably. I gathered the money carefully from a variety of other sources and with it we hiked to a mountain hut above the town of Isenfluh. As Leo Durocher says, luck is the residue of design. The fruit bowl of life, that spinning lazy Susan, flings out goodies and rotten fruit, prizes and embarassments, trips to Europe and long afternoons on us all with some regard for preparation, discipline and good work. But not always. The correlation is confusing, filled with a weird justice in which dream life, emotion, acts of generosity, and guilt seem to fill in and balance an equally spinning conscience.

In this case, I got lots of money and went to Europe, but the show I had in Amsterdam was a logistical disaster and the roads through the Alps were closed with snow. My French was the best ever but we were rushed and no one understood me as well as I did myself. The trip was a hopscotch of fleeting impressions. Here then is my souvenir, before the fact, the best photograph I took of Europe, sitting on the table, waiting for me at home.

LOBSTERS ON THE ROAD

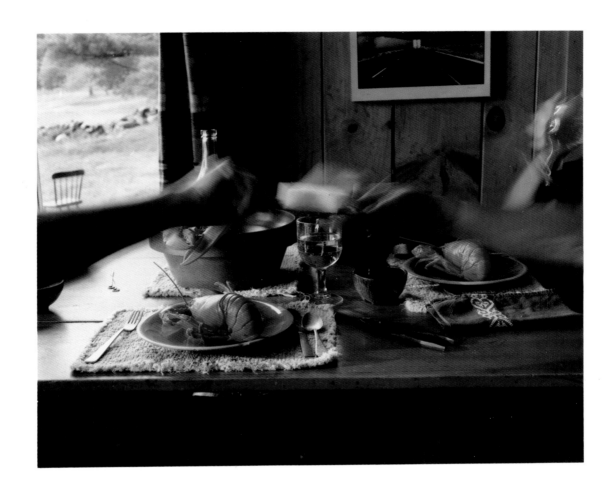

I'm standing outside Reno with my friend Bruce, heading down I-80 for Sparks. We've just ditched Ivan the little Russian, whose beardo-weirdo appearance has kept the rides at bay. We're heading east and the trucks roar past us, kicking up dust, candy wrappers, knocking our new hats askew.

Meanwhile, in deep Maine the lobster king takes a head count of his warriors and finds three missing. At a table in Massachusetts my family sits down to dinner, says a quick grace, and begins to tear into his infantry.

A cowboy stops and we throw our packs into the back of the pick-up. He's turning off at Fernley, going to Yerington, so we've got a ride of forty miles.

The lobster king is upset. He's had enough of this summer crap. His lobster army invades Maine. The coastal towns of Corea and Indian River are wiped out. The lobsters move inland, triumphant, unrepentant.

A mountain lion bounds across the interstate in the Nevada desert. We've been standing at the side of the road for five hours now, on the on-ramp. We can't afford to get a ticket. Ivan had hitchhiked from Boston on fifteen cents. We've got knives somewhere in our packs, we think. Lots of Continentals, old men with white hats and their kerchiefed wives.

The lobsters have reached Akron and have eaten the soap box derby. They are heading for the Mississippi. An eighteen-wheeler finally stops. He wants to know if you boys can drive. We can't fake it but he says hop in anyway. We're moving and he pulls a six-pack from a cooler behind his seat.

The lobsters have torn down the St. Louis arch and have consumed the wheat of the West like locusts. Our ride gets into Salt Lake City at two in the morning. We've hit a deer on the way in and the guy's car has developed vapor lock. If we slow down we'll stall, so we roar through Salt Lake, muffler gone, refineries glowing at seventy-five miles an hour.

The lobsters have reached the High Plains and are headed our way. Back in Massachusetts my family finishes up the three, and their remains are dumped on the compost heap for skunks and racoons.

We're rolling toward Rock Springs in the back of a VW van as the wave of lobsters hits. It's three miles wide and half a mile deep. We crunch through and the guy driving is screaming and we're in the back yelling at him not to stop.

We read all about it in the papers at Rawlins. There's nothing left of Rock Springs. Lobsters, lobsters, lobsters. I call my folks and they're okay.

Bruce and I share a jug of cheap wine and my family is drinking Scotch up at Heath.

The lobsters bog down in the Carson Sink. They freeze up in the Sierras. A few make it down to the central valley, where they're swatted and boiled, and about a hundred scuttle into the Bay Area. They creep into the Pacific at Half Moon Bay, exhausted, having made their point, protected by environmentalists.

The dinner continues at Heath. The guests sit around talking about LBJ, astrology, the younger generation, kick boxing, lobsters. The lobster king, in deep Maine, has taken a bite out of America. Tastes good, he thinks.

Bruce and I head up to Bemidji to fish for walleye. His father picks us up in Detroit Lakes in a Cadillac and we sit back, assaying the world, going a hundred-and-twelve miles an hour.

AT THE RACES

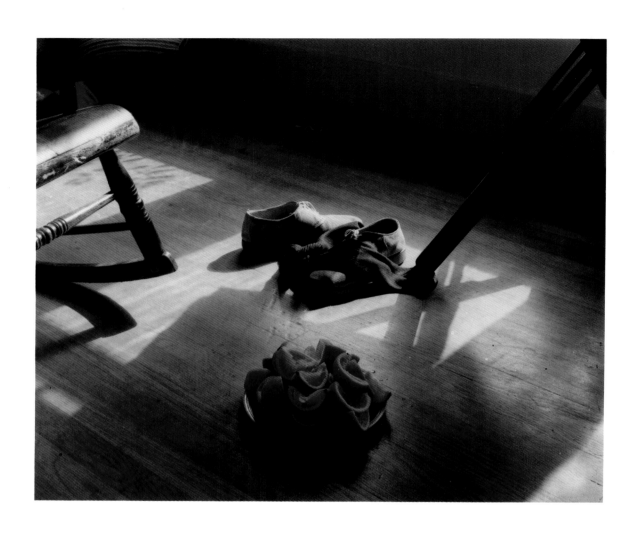

Despite the city shoes, this photograph has to do with the sport of running. I took this after my first six-mile race, the most vivid memory of which was being told that the finish line was only one hundred yards away and therefore to sprint, which I did, when in fact the finish line was a quarter of a mile distant. I found this out very quickly, and the final yards included the anger and agony for which the sport is justly famous. When I finally plowed across I was deeply involved with the sacrificial notions that fill this photograph.

Yet, just past death, in Heaven, there was an occurrence so elegantly simple that I reconsidered everything. At the end of the race there were oranges, cut up, millions of them. Good ones. Juicy ones. Orange ones. Boxes and boxes of them, all waiting patiently to be eaten and discarded. I happily mashed them into my face, section after section. They were so good, and it felt so good to stop running that I began to laugh aloud, surrounded by hundreds of people doing the same.

After returning home I looked in the refrigerator for beer and found more oranges: a five-pound bag. I sat and watched the Astros lose to the Mets and I ate them all. This is about a quarter of the bag. The rest didn't fit on the plate, and, as the plate filled up, I took it into the kitchen and emptied it into the trash. Davey Johnson is taking out Dwight Gooden and Orosco is coming in from the bullpen. The Astrodome is rocking and not until later did we know that our pennant hopes were dashed.

At the moment, Doran is cleaning his spikes. Glen Davis is cricking his neck as only he can, and half a dozen roaches are in a frenzy of waiting in the wings.

To round things out: the slanted contraption is a drawing table, the pillows were made by my friend Debby, and the Boston rocker I shipped on a commercial flight from New York to San Francisco, then U-Hauled, a Mis-Adventure in Moving, from the Bay Area to Houston.

Except for the various smells in this photograph, the sunlight and the hardwood floors, I think that covers everything, and if not everything, then certainly enough.

THE BOGEY MEN OF BORNEO

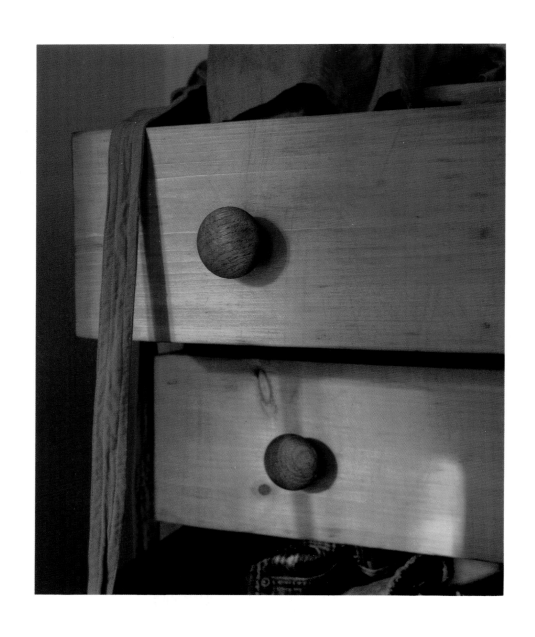

Debby lay sleeping. Around her bed the bogey men of Borneo paraded with their shields and their wide nostrils. They were chanting a night song, and as they danced the bed began to levitate and swing gently in the cool air of the evening. Debby slept peacefully, her black curls on the pillow, her small face peeking out from under the covers, and the bogey men went away. Snakes and large reptiles slithered into the room, but the bed continued to rock gently in the air and Debby continued to sleep.

Outside, the moon rose behind the elms and clear night shadows appeared. A dog slept beside the house next door and the bogey men appeared close to it. They discussed animatedly and absolutely silently what should be done with the dog as it lay in its spot beside the building, snapping at a dream.

Debby slept on. The reptiles had left and the bed slowly settled to the floor. Sand sifted down like a light snow and four friendly dogs padded into the room. They lay down beside the bed, put their heads on their paws, swallowed, and went to sleep.

Debby stirred, rolled over, pushed down into the covers, and dreamed of building a sand castle with a bucket on a beach in Florida, years and years before. One of the dogs was grinning. He had a woodchuck spotted and it wasn't so far away.

A DOG'S LIFE

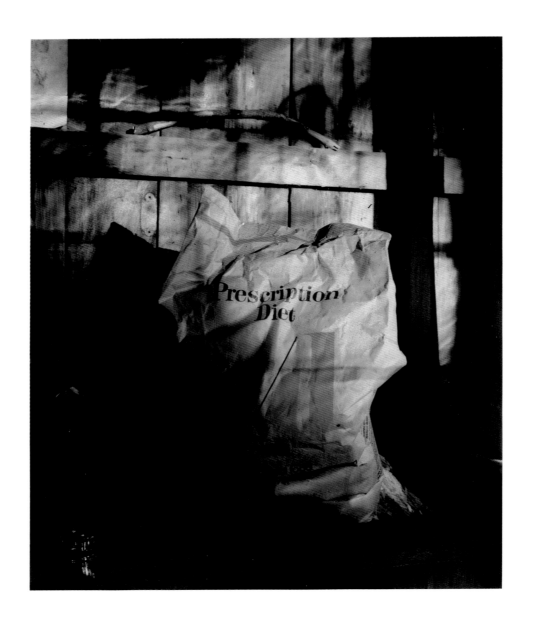

There are many items necessary to the dog's life in this photograph. To name a few: there is food, a lot of it, and food created expressly for an individual dog. There is a throwing stick, slightly curved for sound effect, a classic recreational item. There is a large jar of water for the dog to drink and there is a box of firewood below the bag of dog food, which could be burned for warmth.

There is shelter implied. (The photograph is taken inside.) A pile of newspapers, barely visible in the lower right, could be spread on the floor in the presence of a young dog. There is a topographic map which the owner of the dog might use in taking the dog for walks. Some nondescript tools which could conceivably be used to build the dog its own home can be seen above the bottle, and there is strong warm light in which the dog could lie down and sleep. All these elements add up to a potentially happy life for the dog.

Also implied in this photograph are caring owners (prescription diets and bottled water) and, although it can't be made out because of the length of the exposure, a pet other than a dog may be involved. On the right side of the throwing stick is a severely arched shadow. This shadow is cast by a parrot's perch. My memory is that the parrot was on the perch when I took the photograph, but I may be wrong. Its shadow is not particularly visible, perhaps because the bird was moving. In any case, the dog and the parrot get along very well. Or got along very well. A few months after this photograph was taken, the parrot flew away. Making a big mistake, it now lives somewhere along the cold northern California coast.

But that's not what this photograph is about. It's really about sex. As you can see, the bag is a female torso astride a nude male. She is wearing an h/d Prescription Diet T-shirt and she is ecstatic. She moves her arms and head around so fast that, like the parrot, she doesn't show up. The bottle then takes on other meanings, as do the tools and the stick.

That's not true. It's about spiritual light on mundane things. The sacred and the profane. The sacred wood and light and the profane dog food.

And even that's not it. It's about color and texture. Similarities of color. Differences in texture.

What's that strange shape above the Prescription Diet owl's right ear (when it's facing you)? It looks as though a drawer pull or something used to be there. The owl is staring at you. See its h/d eyes and perked ears? It's a holy owl and has a throwing stick halo.

It's a dog's life. Prescription Diet is a punching bag, a tackling dummy, a sack containing three thousand hamsters, empty, full of charcoal briquettes, and an element in a story still to be told.

A shaggy dog named Hunter-Driffield once invented the H/D curve of photographic exposure. It was the end of the intuitive and the beginning of the scientific in photography. Equivalences never were quite the same after old HD and Alfred Stieglitz, the shaggy dog's elegant owner.

A DAY AT THE BEACH

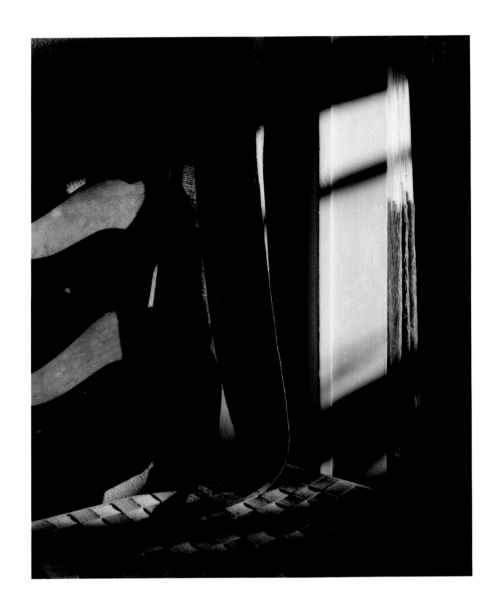

We are lying on the beach outside Veracruz, sipping out of a coconut shell, fried. The palm trees wave at us across the dirty sand. I'm thinking of a Shaker barn in Hancock, New York, when a little kid in a parasail crashes down in the bay. His mother begins to scream and a black dog runs barking up and down the water line. A fat man in a red bathing suit hustles through the soupy waves to get the kid.

The idea of order in Veracruz. I find myself playing a lead in a B movie. Where are the credits, I wonder. When do I wake up?

I rumble to my feet to help. The kid looks fine from a distance.

Shaker barns are the A movies of architecture, I think brightly. They crackle with function. No lazy summer grace notes there. Elegant, rigorous, cool, stiff-backed.

The dog has chased the fat man into the waves and has bitten him on the leg. The kid has become entangled in the parasail and is screaming. Everyone's up helping, trying to call off the dog.

The Shaker barn has caught on fire and the Shakers have formed a dancing bucket brigade. They throw water on the fire with their beautiful buckets. The cows moo and Methodists from a nearby church rush to lend a hand.

We have pulled the kid out of the surf. He was wearing a bright yellow neoprene life preserver all along. The fat man is limping off down the beach, cursing at the dog, and the mother is crying hysterically. The fire goes out at Hancock and the sun begins to set. We go back to what I decide are piña coladas.

Not much to do even when there's action, I think. My book, I notice, seems to have been washed out to sea. It was a huge book, *Ada*, and I hadn't finished it yet. The tropical sun slants down on us and we wonder what to do for the next few hours. It's too early to go home and we've done everything else.

The Shakers continue to dance. A dance of victory among the smoking embers of their barn. They've gotten the animals out and will rebuild around the stone. It's all too soft, too muted, too unclear I think as I fall asleep on the sand, dreaming of a summer night at home, dreaming of stars.

REMBRANDT AND THE
SOUTH CHINA SEA

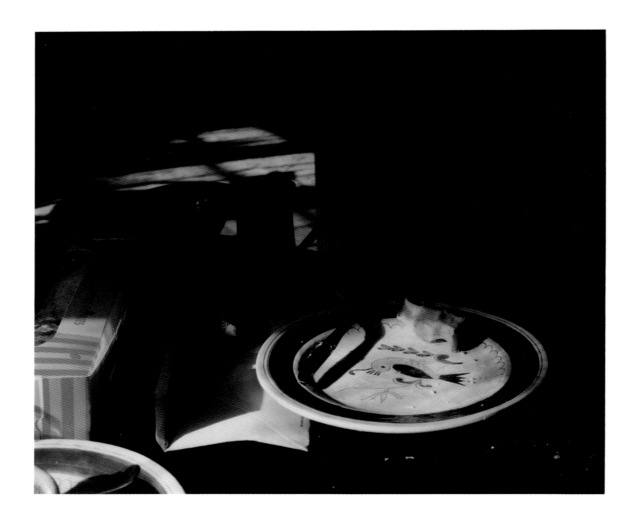

Rembrandt was walking down the hall to clean out his brushes on the porch when the telephone rang. It was his brother-in-law from Antwerp. (He hadn't seen him in over six months, and the last time they had been together the relationship had seemed strained — an unpaid debt, an unhappy sister, etc.). Yet Rembrandt was cordial and stood in the hall talking to Roger, who seemed to be trying to talk him into backing a neighborhood fast-food venture. As he talked, his paint brushes dripped a mixture of turpentine and oil into the new carpet. It was oriental and had recently, very recently, arrived from China. It had traveled by boat through the South China Sea, around the Straits of Molucca, across the Indian Ocean, up the Cape of Good Hope, and on to Amsterdam, where Rembrandt, in consultation with his wife, had bought it the Thursday before.

His wife passed him in the hall, carrying a steaming chicken casserole.

"Look what you're doing!" she said.

"Christ," said Rembrandt. "Look, Roger, I gotta go. I'll call you back."

"I really think this might work."

"I really gotta go. I'm getting paint all over the damn rug." Rembrandt had the phone craned into his shoulder, and the paint was dripping into his hand.

"Good God," he said, trying to hang up the phone without getting paint on it and without dripping any more on the floor. "That guy will never learn," he said to his wife, who was bringing a pitcher of milk out to the table on the porch.

Rembrandt went over to the sink, poured out some more turpentine, and began to clean his brushes.

"This rug is really a mess," said his wife.

"Look, I'll clean it up. I'll clean it up."

He stared out from the porch, out over the harbor, and watched a boat in a pocket of light. There were some nice clouds. He wondered what China looked like. He had seen some pictures but hadn't believed them. Those were very strange-looking mountains. Maybe Roger was right and they could make some money off this shop. Then again he might lose a bundle. Who was to say? He went back to the table and sat down to lunch. Time to do another self-portrait, he thought.

STEVE WOLF SITS AT THE TABLE AND THINKS

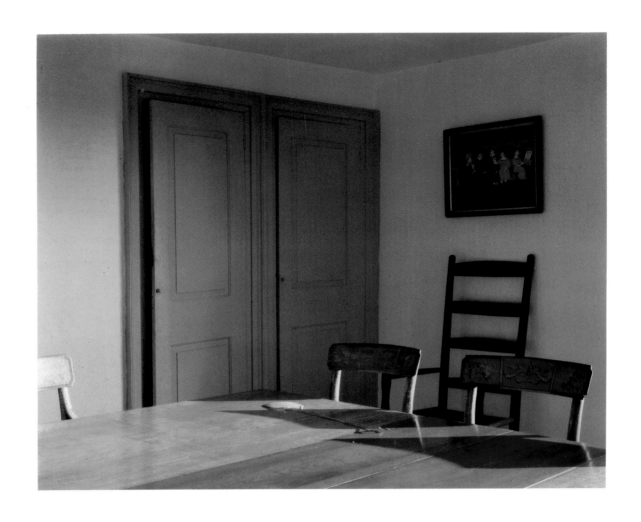

The spirit of Steve Wolf sits at the table listening to conversation and thinking. He eats spaghetti with care, answers a question on beaver dams with a dry twinkle, and thinks random summer thoughts: of his recent death and of baseball. He remembers hitting a triple in Colrain, sees his Little League T-shirt, red with a white C folded in his drawer, and thinks of his coach Joe, of his cigars, his humor and his care.

He thinks of big brothers and of hiking, all the miles and all the mountains seen: the Long Trail, the Muir Trail, Pioneer Basin, Haystack, Greylock, Stratton, Katahdin. He dances to Shaker tunes on the shoulder of Jefferson, to the winds and mists and rocks, with heavy boots and a free mind.

He sits at the table, thin and strong, six feet five, blond hair and red-blond beard, reading in the afternoon light. A sixty-pound Fred Bear recurve bow appears in his mind. He thinks of targets and woodchucks, of St. Sebastian porcupines and lost fru-fru arrows, of stalking through the dew in the spiderwebs and morning glories at dawn.

He thinks of evenings at Heath, of twisting the swing like a rubber band plane and watching the maples spin, of pulling carrots from the garden and wiping the earth off on the grass. Of kick-the-can, sardines and capture-the-flag with the Porters, Wolf girls, Wallers, Roberts, and whoever else was there, all finally packed under an apple tree, hot, sweaty, sexy and laughing. He thinks of Sand Springs Golden Dry Ginger Ale and ginger snaps, and of fishing: orange-pink fleshed trout at the Baileys', three billion bluegills from the Eldridges', a huge pickerel in Millinocket, Maine. Of brook trout after brook trout in the Sierras and of not enough Noodles Romanoff, Rice-A-Roni, or freeze-dried Beef Stroganoff, many, many times.

His mind moves to Cambridge and he sees the photograph in his room: champagne at Mono Pass — Tim and Mark with Mark's drawing above it. He thinks with an astonished start of problems: of cleanliness and keeping clean, of law school and television, of gum, mouthwashes, and the fear of leaving the house.

He remembers hitchhiking, cross-country flights, and a row of cantaloupes he was to hoe which did not have an end. He thinks of guinea pigs and rabbits, of croquet in front of the roses, of friendship with Marko that began in diapers. He thinks of thumbsucking, cinderblocks, the building of a house, and of all the doctors, hospitals, corridors, strange rooms, and strangers. He thinks of unknown faces that once did not threaten, of fears that finally stay,

of recoveries repeatedly torn, of saying good-bye, and of flying like a phoenix into thoughts, dreams, and memories.

He thinks of Bill and Eleanor and Ned and John. He thinks of all his friends and relations. He thinks of being smart and funny and wise and having it all gradually fade.

He's lying in the sun on the hot asphalt beside the pool, resting on the smooth rocks at the Gorge, propped up on his elbows on the stubble by the pond. He's swimming, canoeing, eating hamburgers, tuna fish sandwiches, and someone's casserole at Harriman. He's at ease and talking.

He sits now at the table thinking, able to roam and return. He has friends to talk with, long walks to take, a dog named Hugo as big as he is, and an eternity of fresh mornings to explore.

He visits all of us. We greet him, he greets us. The solidity that never left him is full and strong, and his smile is one of love, understanding, and forgiveness.

BURGLARS

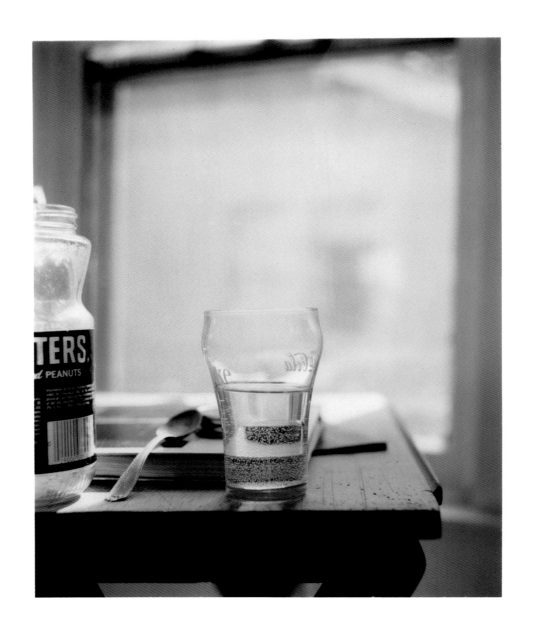

When the burglars hit, this is what they left me. The dust at the bottom of the peanut jar, a bad bent spoon, and a Coke glass filled half-way with dead water. Broken windows — everything the way you'd picture it. Stuff strewn around. Do I barricade the back door? If I keep a baseball bat beside it, will I break arms? My grandfather's watch. All my cameras. This is a new world then: a glass of water, dust, a spoon, a book, and some sunlight.

MEDICINE MAN

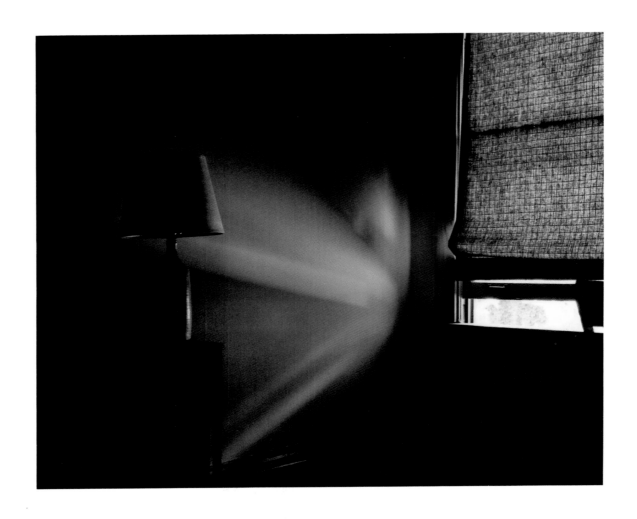

In northern Minnesota, beneath the Dog Star an owl is hooting. Deer are bedded down in the ferns, pines sway in the light wind, and an Indian camp sleeps by Lake Ochikwa.

The medicine man Ojeewah-hatta sits in his tent and ponders. He is an old man and has seen many things. He is worried about his people and about his own future. He begins to chant softly.

On the other side of the lake a loon begins to cry. The old man listens and ponders, listens and ponders. His moccasins no longer fit him, his stomach no longer works well, and all those around him seem to recede, as though he were moving away from them very slowly but perceptively. He takes out a knife and cuts a strip of moose jerky from the piece beside him. He chews on it thoughtfully. There is light, a faint blue-grey at the other end of the lake. Dawn will come, and another dawn, and another and another. One day he will not be here. He chews on the moose jerky, falls asleep, and dies.

He slowly ascends into an afterlife and there dances in the sky. His job is to dance the dawn into morning each day, making sure that it appears and disappears with all the ease, grace, and complexity possible. This he does before all creation: the fish, the deer, the beavers, and a quietly entrusting God who speaks with him about his work each afternoon.

DECISIVE MOMENTS

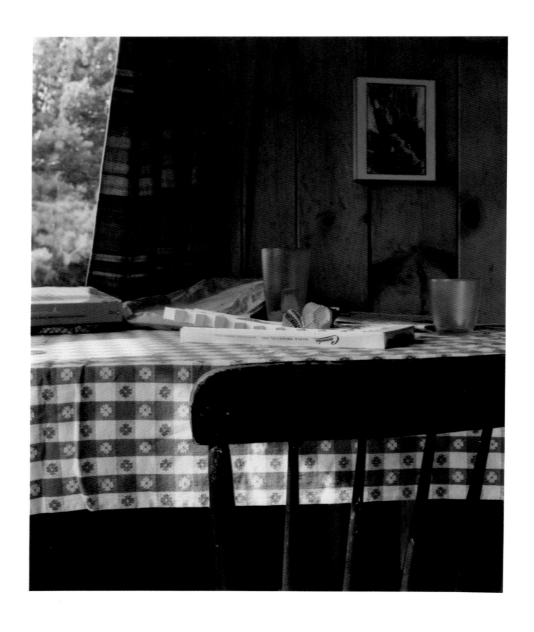

One summer when I was sixteen I was given a tour of the Coombs maple sugar factory with a large maple sugar maple leaf stuffed down the front of my bathing suit. The tour caught me by surprise. We had planned on going in on a quick guerrilla raid to buy cheap seconds, and I had swiped the candy from a tray. Suddenly a white-haired woman appeared from nowhere, and into my trunks went the maple leaf. The tour was long, the day was hot and after ten minutes I was very uncomfortable. It was one of my first thefts and I paid for it.

Ten years later Debby and I sit at a table in an Amsterdam cafe. To get to the cafe it is necessary to walk down half a dozen steps. Street-level windows let light in, and in the late afternoon it streams into the air, clear and golden. We eat sweet rolls, drink our coffee, and talk with a Dutch graduate student and a South Moluccan islander about colonial problems in the South Pacific. The Moluccan is serious about hijacking a train; he has been so for some time and the graduate student is trying to talk him out of it. There is such sweetness to the air, the food, and the coffee that the surreality of such a conversation in such a place makes me begin to feel like a participant in a dream. We all seem to be floating and very easily might fly away, out over the cobbles, the canals, the churches, Anne Frank's house, and up into the apparent softness of the Dutch sky. Back to the tropics and Micronesia.

At age eight I stand above Halifax Gorge, up above the falls on the smooth rock. The water rushes below and I can feel the sun on my back. It all seems very quiet and I can feel a thousand eyes on me as I try to force myself to take that first pushing step out into the air and down. I make two false starts and then kick out, surrounded by terror and absolute silence. I hit the water, feel the cold and the force of the current, and bounce up hollering with relief, exhilaration, and pride.

SUMMERTIME

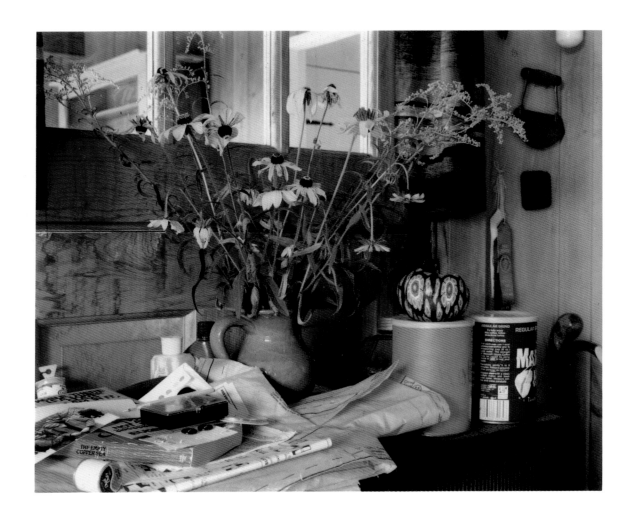

Summers, when I was young, used to stretch across time like the sky above our summer home. There seemed room in a summer to do all the things the days suggested and the imagination demanded, as long as school was kept at bay. School hung there in September, bat-like, waiting for us with its dusty wings and knowledgeable fangs. In June and July this was easy to forget, but by the second week in August, when the Back-to-School sales hit the Greenfield *Recorder-Gazette*, we knew it was only a matter of time. That suffocating feeling of being pulled into yet another year of folded hands and clenched jaws would seep into the day and poison it. We knew how to read and count. What did they want?

We did not want to grow old, that was clear. We didn't like what we saw. We recognized a good deal when it was dealt us, and as this knuckleball of educational maturity approached us, we had the good sense to back out of the box and wait around for something a little more direct.

SEASONS OF LIGHT

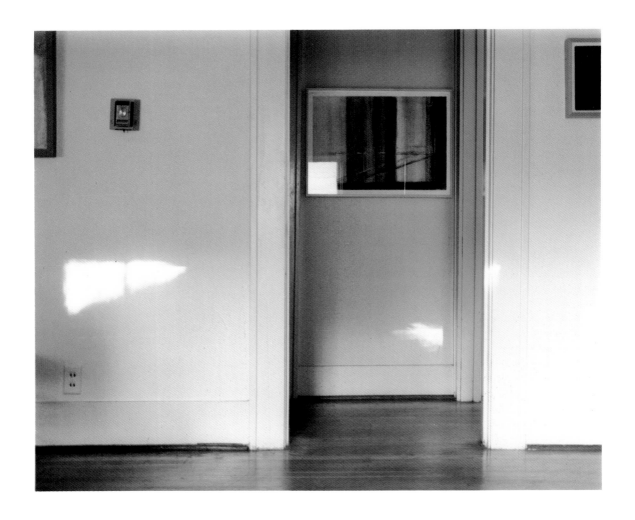

Years ago in the dead of winter when the wolves howled on the steppes and sleigh bells rang, we lived in a large country house outside of Valushnakov. In the summer, as the poplars danced and the cornflowers swayed and the clouds swept across the land, the light would dapple the living room in the late afternoon. We would play connect-the-dots and discover bears, zebras, and monkeys in the trees.

In the fall we sat by the fire, and as woodcutters shouted and chopped and apples fell, we would watch Uncle Altman draw for us: pictures that worked from two directions at once. Frowns would change to smiles as he turned the page.

The wind blew in the spring, and on the pond, ripples would begin above the pike. There would be the sounds of birds and leaves, the sounds of skirts and petticoats in the undergrowth, the soft snorting of a horse, and from the kitchen, singing and the smell of baking bread. Throughout the year the light would filter through the tall trees in front of the house and the clarity of the seasons would be washed on the walls, etched and shining, hinting at questions we would try to remember but did not yet understand.

VERMEER WILL BE 368
IN THE YEAR 2000

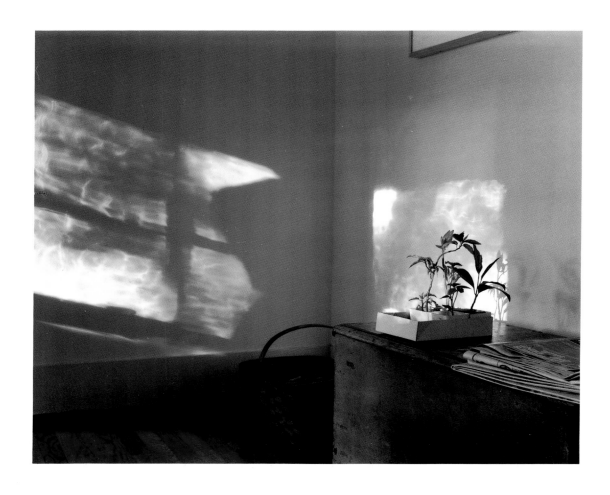

Jan Vermeer dreamed this photograph on October 11, 1665. It was a detail in a longer dream involving an animal, a chase on horseback, a group of carnivorous plants, and a set of forces that had the ability to reduce material things to their essential forms.

He woke up in a sweat, his mind moving quickly from a concept to an image and back again: miniaturization, frozen moments in an episode of terror, beauty captured within a continuum, the food chain. He stared at the ceiling, thinking for a moment, then got up and walked over to his camera obscura. He peered into it, pointed it at his dog, asleep in a spot of light, and snapped his fingers.

Eldrin, his model, rolled over, got out of bed, and shuffled into the bathroom. Vermeer looked at his drawing pad and shook his head. He wasn't sure whether to try to remember the dream or not. The decision, as well as the dream, seemed to have something to do with continental drift, a theory with which he was not familiar. The term "plate tectonics" clattered through his mind.

These linguistic visitations had occurred often lately. In some ways they were a daytime parallel to his photographic dreams and had at first been interesting. Recently they had begun to concern him. He picked up a piece of charcoal and began to sketch tentatively. He had been working on the hand of God, a kind and open hand that seemed to assume nothing.

Vermeer had dreamed fifteen photographs in the past week. There was a Garry Winogrand that he had liked particularly, and a William Carlos Williams poem that his dream had turned into a single photographic image of a crow. Three Robert Adams, six Atgets, one Weston, two Walker Evans, and a Lartigue.

He continued to sketch the hand of God, which was becoming mottled and unclear. He tried to remember if he had seen begonias in the photograph in the dream. The colored newspaper was certainly something new, as was the animal, which began to turn into a dog as his memory of the dream faded.

His studio was a mess. He had been chased over the countryside, he remembered that — the wind and the horse and the certain knowledge that they would never catch him. He had turned into a hawk, just as the men who were chasing him had drawn near and he had flown off, leaving them angry.

The photograph came moments later. He landed in Houston and returned to human form. He wandered into my house for a cup of coffee, sat down, and noticed the photograph in the

corner. In retrospect he thought he had remembered seeing the photograph in the picture frame in the upper righthand corner of the photograph itself. Could that be? He couldn't remember if he had simply seen the photograph as part of his dream or if he had seen the photograph, and in the picture frame he had seen the sketch he was now doing of the hand of God. I brought him a cup of coffee. He remembered sitting at the table and watching the light move across the room. He thought that that had been the end of the dream, that the coffee had awakened him. He then remembered thinking that the light wasn't moving across the room, it was the earth moving in relationship to the sun that caused the apparent shift of light on the wall. It wasn't the light moving at all. It was the wall. Everything was suddenly in flux.

Eldrin came into the studio with a cup of coffee. The two sat down to breakfast. Vermeer kept glancing over to the hand of God. His dog stirred in the corner. What about the plants? he thought to himself. What about the plants?

WESTMINSTER ABBEY

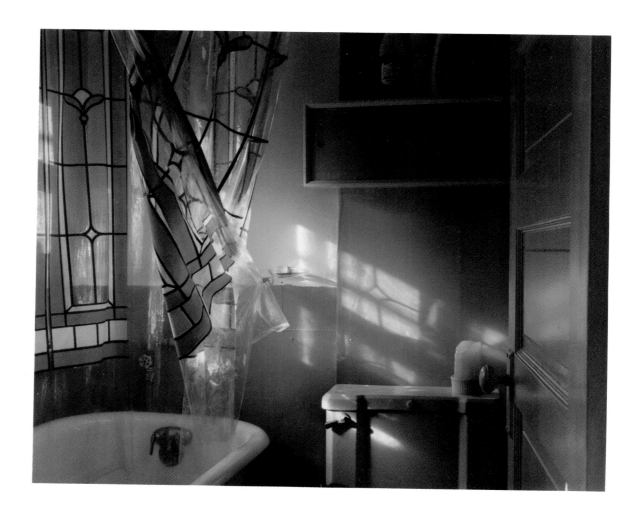

This is the bathroom of the souvenir shop in Westminster Abbey. The first time I saw it I had just finished a lunch of steak and kidney pie, I had visited the grave of Robert Burns and had bought a postcard of John Milton. I was bowled over, transfixed by the light, and I left quickly to get my camera.

When I returned, a small black and white cleric followed me in and stood beside me as I took the photograph. He appeared to be on guard, as though he wanted to make sure I did nothing obscene to the souvenir shop bathroom.

"I photographed this once," he said.

"You did?"

"Yes. I showed it to Fredrick Henry Evans. He didn't like it much."

"Really?" Fredrick Henry Evans had photographed cathedrals in the early part of the century. I didn't believe a word of this.

"Yes. He said it was gaudy."

"I guess it is gaudy." I looked around the room. "If you can't make it right, make it red."

"What?"

"If you can't make it right, make it red. A photo-historian, Beaumont Newhall, said that."

"Who?"

"Beaumont Newhall. He's a photo-historian."

"Oh." He watched me working. "That's an interesting way to meter."

"What?"

"I say that's an interesting method you're using to meter. I wouldn't do it that way."

"How would you do it?"

"I wish I had time to explain. I have a small group to show around the abbey. Nine of them. Waiting."

"You're a guide?"

"Yes, I am." He was leaning against the wall, arms folded. "Well. Good luck with the photograph, though I don't understand what you see in it."

"You photographed it. What did you see?"

"Oh, I was younger then. Much, much younger. Much more naive. I really must go. Good luck."

I took the photograph, wishing as I did that the film could somehow rip the walls out, walked outside and watched as the sun went behind a cloud. It looked like rain and I was hungry again. Bacon and eggs, I thought.

I've always been surprised by the lack of irritation in the photograph itself. It didn't occur to me until much later that the man simply wanted to use the bathroom.

WIMBERLEY

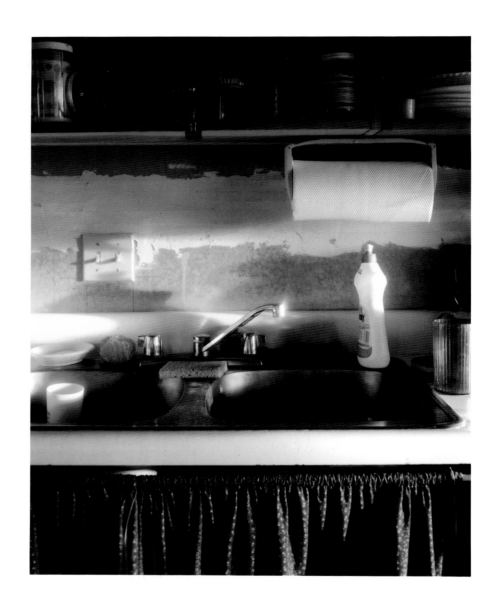

We know when we're home even if we're not. Double sinks, an unfinished wall, Ivory Liquid, a red and yellow pot scrubber, sponges getting old. We've been here before. We know the light and we know the moment.

We can feel the rumble of the garbage disposal as we hit the switch and we sense the softness of the roll of towels. They will hang up, we know, when we unroll them. They've been doing this for months.

Order above — the salsa, the plates, the cups — we know there will be a garbage can below. We like the people who have made this house and we wish they were together still. Margaret sewed the curtain. Lee built the shelves. Kiley spackled the sheetrock, and one of them concerned with order hung that little clip from the board. These are particular people in their own home, without pretense, in no hurry and at ease.

THE DICTIONARY TWINS
IN THE HEBRIDES

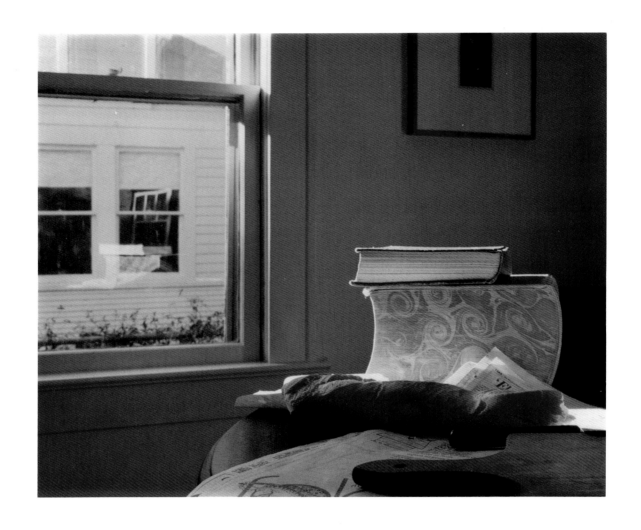

O nce upon a time'' is a phrase that perfectly describes the photographic process. The photographer Lartigue, as a boy, used his eyes as shutters, opening them to let the desired moment in, shutting them when he felt he had captured it. Discovering to his dismay that this was not enough (his memory would not hold all the pictures he wanted to save), he began to photograph: each time once, each time surmounting time.

Once upon a time the wife of the Chieftain of Barra gave birth to twins. One, Ferrell, was short, fair, and straight-haired while the other, Geordie, was large, brown, and meaty. Twins could not have been more dissimilar.

After their twelfth year the twins were separated and forced to live on different islands. Their father, the Chieftain of Barra, and his rival, the Chieftain of Colonsay, had entered into a pact of friendship: since the man from Colonsay had a boy the same age as the twins, the two chiefs decided to put aside a century of quarrels with a trade; each would raise the other's son as his own. There was one problem. Barra had not told Colonsay that he had twins.

In a ritual exchange on the island of Islay, Barra gave up Geordie, leaving Ferrell at home, and Colonsay innocently gave away his son, Malcolm. The light shone down on the Hebrides, illuminating the crofts and pockets of blue in the sea. The twins, separated by the water, felt the distance between them strongly. Each bore a burden: Geordie had been instructed to keep the identity of his brother secret, while Ferrell was kept constantly disguised for fear of discovery.

Everyone was unhappy, not the least being the Barra, who had planned to murder young Malcolm, ending the rival clan's line (for the man from Colonsay and his wife were old) while at the same time maintaining his own through the hidden twin. He quickly found that this was something he could not do.

After a time Geordie understood. He saw that if Malcolm died, he would die as well and he carefully considered his choices: death, emigration, a return to home, or falling to his knees before Colonsay in confession.

He decided on the last. All unraveled. Ships were sent from Colonsay to reclaim Malcolm, and shortly thereafter the Barra himself pled for mercy. It was a greedy mistake, he said, an action he had taken in his mind but one he could not complete. The Chieftain of Colonsay, though troubled, forgave him. His son was safe and the feud seemed to be over. The two shook hands, the children were returned, and all seemed to be as before.

Things were not well with Geordie, however. He could not forget. He knew that at one time his father had been content with the thought of his death and he could not reconcile this

77

with the man he knew and loved. His friendship with the favored brother was shaken and then destroyed.

He left the island one night in a small boat for the mainland and traveled to America. There he lost himself in work and in a family of his own. He thought often of his father and brother, however, and of all the sea and clouds that separated them.

As time passed, work went well and he became rich. He grew old, and in his old age returned to Barra to see his brother once again. There he found that his twin had long since died, the homelands had been sold, and his nieces and nephews had not been told of his existence.

Yet strangely he and Malcolm became friends. They spoke often of their fathers and of the twin, and as they spoke, their story was heard, and as it was heard, it was told in turn.

AROUND THE WORLD
WITH JOHN CAMERON SWAYZE

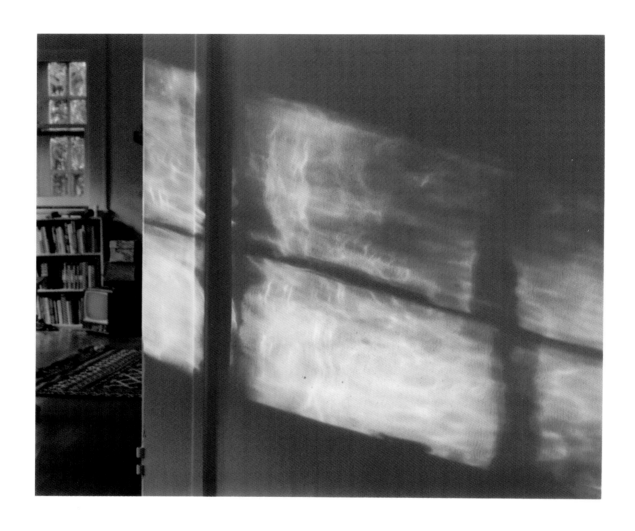

We stand with John Cameron Swayze at the cliff above Acapulco. The diver with the Timex checks it against his ear. He grins and we know it's ticking. Off into the air and down he goes, hitting with a splash and bobbing up moments later, again grinning. There is a roar from the crowd, and then a second more urgent sound: a dorsal fin, large, has appeared behind the man. The diver begins to swim away fast, then turns, takes off the watch, and hurls it at the shark. The watch hits the shark in the middle of its open mouth and the fish turns away, coughing and shaking its head. John Cameron Swayze is very excited. A new use for the great American watch. It will repel sharks. And that's not all.

Three years later we visit with John Cameron Swayze in the comfort of his Fort Lauderdale condominium. A local fisherman, Bob Dole, has caught a shark and in the stomach of the fish, welded together with intestinal encrustations, are a Zippo lighter and a Timex watch. They are not in the best shape, but John Cameron Swayze shows us that they both work. The lighter lights and the watch ticks. He holds them aloft above his shag rug, ticking and burning as a photographer walks in front of the television lights and takes a photograph.

A year later, on the ski slopes of Aspen, John Cameron Swayze moves slowly down through the powder snow, clicking off the miles with a new ski pedometer. Down, down, down he goes, singing a song about flying crows, content for the moment with the solitude.

And very shortly after this, a man dressed up like Zorro practices sword swipes with an imaginary sword against the whitewashed wall of a Mexican prison. It is the cliff diver. His mind is gone. "Take that, Sergeant Garcia!" he says. He has robbed the Eckerd drugstore in Acapulco six times.

This final item concerns the cathedral in Rouen, where a priest in a brown cassock kneels and prays in the clarity of stained-glass light. He kneels and prays for us all: John Cameron Swayze, Zorro, the diver, Bob Dole, you, me, Moses Malone, himself. He is an old dying alcoholic priest, and he is praying as diligently as he can.

BREAKFAST NATIVITY

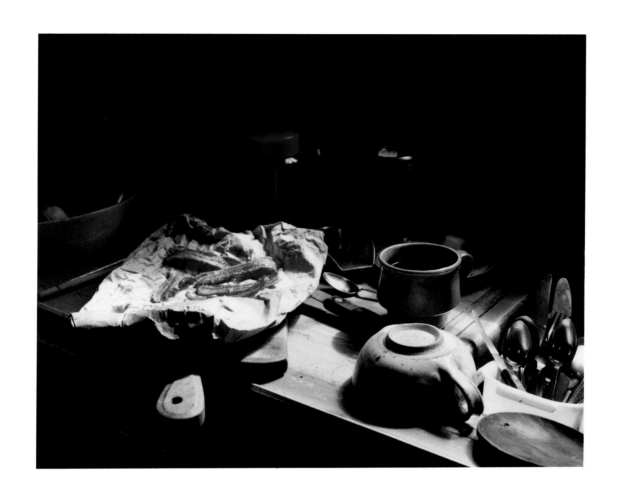

Instant coffee Joseph, a squash camel, kneeling wiseman cup. Mary is distant in her blueness, surprised at this recent event. The sheep spoons are penned in their plastic corral and the butter lamb, who is good and will not run off, hovers behind the Virgin. A couple of dark kings with gold crowns from the mysterious east The main problem with this scenario seems to be the baby Jesus as five pieces of bacon. That's an acceptable paper bag manger — but questions of dietary law arise.

This photograph seems to be about communion. Easter not Christmas. Bacon in a manger and Christmas to Easter, each meal a mouthful.

THE CONFESSION
OF THE GIFT HORSE

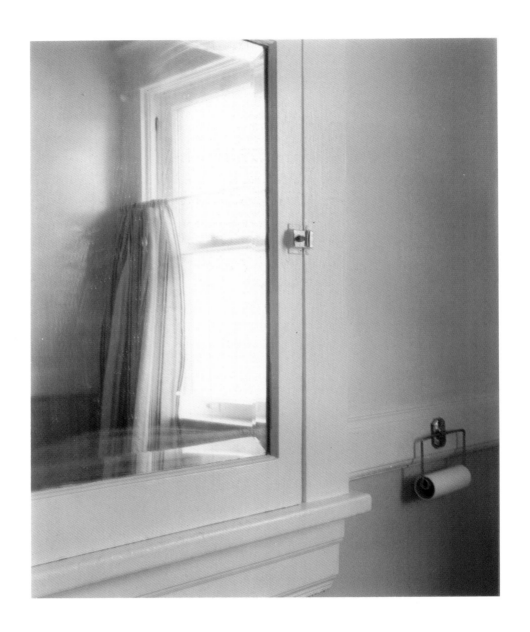

Life and photographs can be gifts, free, simple and clear, offerings that demand little in return. Yet when these gifts appear, we're shocked, mistrustful, idiots from the city caught checking the teeth of the horse, amazed that such a large, graceful animal is stomping around in the bathroom.

What are we supposed to do with it? We'll have to feed it, water it, take it out for walks, buy it a bridle, a blanket. Shoe it, feed it oats, special treats. Have we considered what a present-day veterinarian charges for house calls? Will it need shots? Not to mention curry brushes, dental work, and repairs to the floor. How do you housebreak one of these things? What language does it speak? What sort of emotional commitment is required? How long will it last? Will it win at the track? Will it provide transportation? Will it be fun? What are the odds on it all?

It's nice though, we think, awed by the beauty, the unassertive strength of the animal.

And where did it come from? What have we done to deserve this?

Could it be a trap? Wait a minute, we really don't deserve this. It must be a trap. This thing is going to die and the carcass will get stuck in the bathroom and we'll have to call friends to get it out and they won't get there in time and rigor mortis will have set in and we'll have to prop it up and push it out or saw off legs or something — O my God!

The repercussions from a potential photograph are simpler. The best seem to be presented. Something is offered. We take it or we don't. If we don't like it, we don't have to print it and no one will be offended. There are more important things to worry about. Horses, vets, people, shots, love, beauty, anger, honesty, loss, and pride; things the photograph can at least point toward.

It's a pretty good racket: a parallel world that helps to shape and define the original without the immediate crush of human misunderstanding. Emotionally cost-efficient, at a base level photography can be a series of beautiful bucks passed. I see it, I love it, I take it, I give it. Simple and dumb, but a gift is a gift and if it comes from love the strings that are attached are pretty loose.

MICHELANGELO AND THE BULL

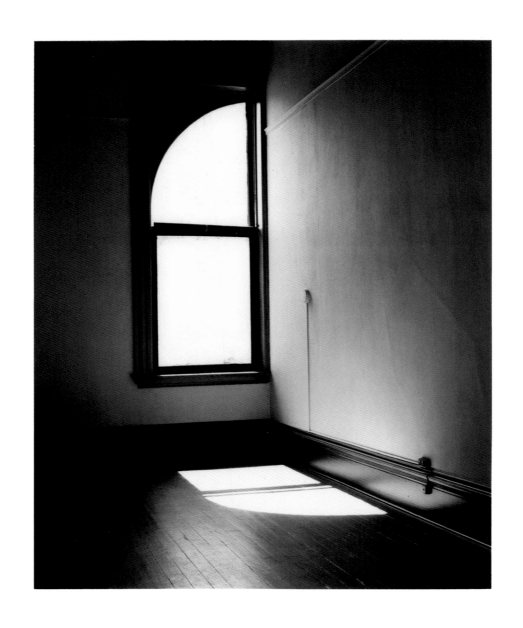

In an upper room of a chateau by the Loire, Michelangelo sits at his desk inventing photography. The ghost of St. Jerome hovers above his head and lambs and lions are curled in the corners of the room. His pen scratches at the parchment as he puts the finishing touches on an instant camera system. This system has been designed with an ethical brain. The camera will be hooked up via lasers and telecommunication devices to a computer in Nantes. The combination of the camera, the computer's visual memory, and its programmed ethics will weed out the bad pictures. It will develop and print the good ones. It is as simple as that.

Far, far away in Palo Alto, a young couple has been fighting for over an hour. There have been pauses in which they have tried to pull themselves back together again and forget, but in each pause a nagging question comes up, and, uncertainly, one or the other begins to speak, haltingly at first, trying to understand, and then, very quickly, hurt, defensive, and angry.

The angels and Michelangelo are crying in the grey clouds above Toledo. Michelangelo looks up a moment, distracted, takes out his camera and photographs El Greco. "This is no time for a photograph," says El Greco. "I'm just testing it," says Michelangelo, putting it back into his bag.

The one-eyed king of Toledo is marrying a beautiful woman. Although dogs and monkeys run the streets in celebration, the alleyways hold men with knives, women with piercing glances, and children with false smiles. They lurk in the shadows like eels. Outside the city a knight fights backward, uphill through the white rocks of the Spanish countryside. Swords clang in the distance and thunder rolls across the sky.

Meanwhile, the young couple has become subdued. They are sitting in a rocking chair, holding each other and rocking back and forth. They are saying kind things and are trying to repair damage. The phone rings, the doorbell rings, and the whistling kettle begins to scream. They look at each other, shake their heads, go to the kitchen, turn off the water, come back to the rocker, and continue to hold each other through the noise.

Michelangelo is trying to photograph a fighting bull in a pasture outside the Escorial. The camera won't work and all he can figure is that there is something immoral about the colors. Is the grass too green? Is the bull too black? The sky too blue? He is becoming truly irritated. It has occurred to him that nothing he points his camera at will be recorded. There

is something wrong with everything, apparently. He begins to curse the committee that programmed the computer. He switches off the terminal connection and Nantes beeps into the distance. There's the bull. He crouches low and takes the photograph. The first ever of a Spanish fighting bull. He looks at it, shows it to El Greco. The two shake their heads. They can't believe it. They spend the rest of the week photographing until they run out of film and then return to their respective cities, Michelangelo hitchhiking back up to Amboise where he dies three weeks later, and El Greco by donkey to Toledo.

Michelangelo's photograph of the fighting bull is now in the Gernsheim Collection at the University of Texas in Austin. El Greco's photographs of interior light in the Escorial are in the collection of the Bibliothèque Nationale in Paris. This photograph was inspired by one of his.

DON'S HOUSE

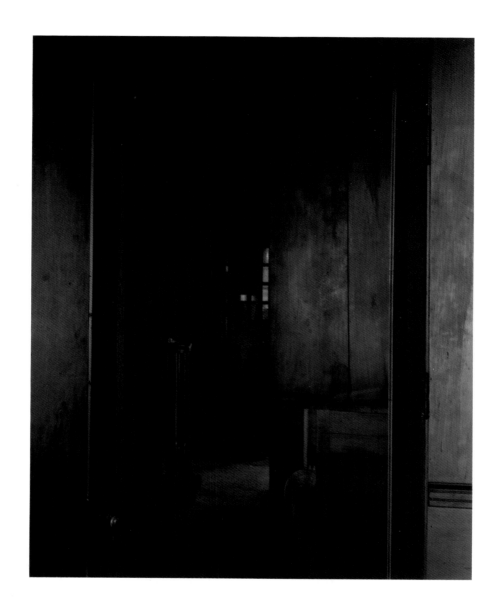

Dominican monks lived in this house at the turn of the century, in this home by the bay in Seabrook. I see them cowled, padding through the halls, chanting in soft Texas accents. They eat mangos together in silence. Long rows of monks at the table.

This mirror went in with the second occupants of the house. The church sold it to a gambling man who ran his roulette wheels and card games downstairs and a whorehouse on the second floor. Who knows the boozy stories the mirror might tell? Guns, hurricanes, gold. Songs of the sweaty South.

The gambler sold the house to a quack doctor who used it as a summer home for the emotionally disturbed children of wealthy Houstonians, crazy kids who sat on the splintered porch swings, staring out to the bay, watching mullet jump. Glassy-eyed, tight-necked children who darted around the house like fireflies.

Ghosts wander these stairs now, according to my friend Don. Don bought the house from Newton Tubbs, who bought it from the Rat Bag Cooking Club. Don is a psychologist who believes in the home's past, as well as its beauty. So do I: my wedding reception was here, and as my father, a minister, blessed us and our friends, I imagined the monks, gamblers, prostitutes, kids, and cooks toasting us.

Dancing in the soft light to the Cajun band, this past waltzed by us on the afternoon breeze, exorcised and harnessed, rich as gumbo, as life-giving as the air that bore it along.

LOVERS

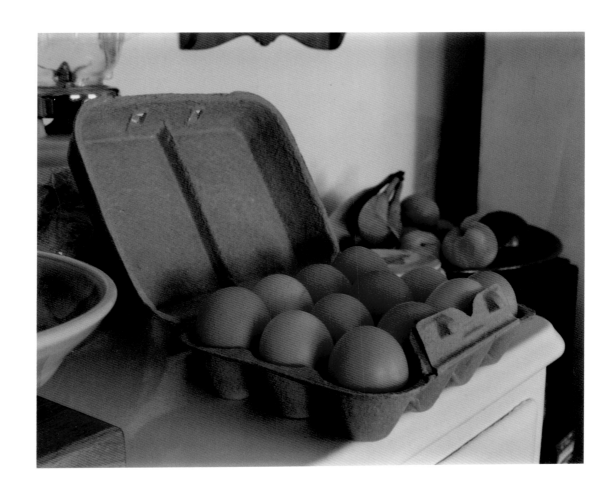

Calm moon above the water. A gentle motion of the tide in the Sea of Japan. Love pours from the evening sky as the lovers stretch and turn. The moon pulls, the tides heave. Fishermen fish with lanterns, with cormorants beneath the Japanese moon.

These eggs are willful, infatuated, love drunk. They creep out over the abyss, serious, curious. They float out the door and love dances a quiet heel and toe, heel and toe before moving on.

The tides of Japan recede and the sky closes in on itself like a lacquer box. The box floats in the sky above the Inland Sea, and the lovers return to it each June. They leave flowers and little messages, tokens that live and breathe in the twilight air.

These eggs are warm and fertile, and the mothers and fathers of the world unite to make them so.

THE BEDROCK OF GOD'S HIGH SCHOOL

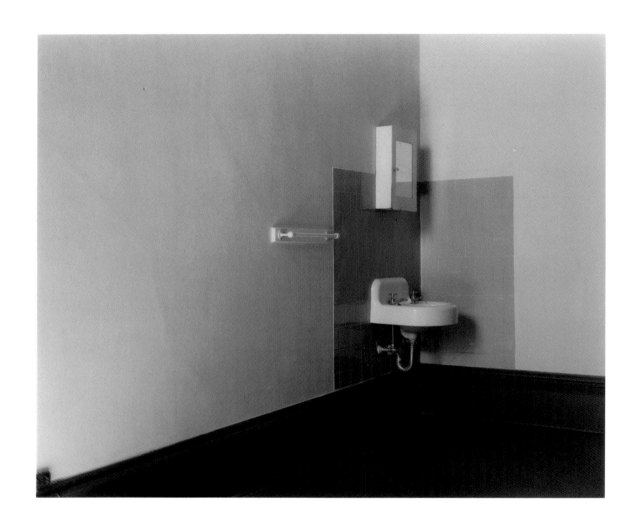

At one time or another Ansel Adams, Timothy O'Sullivan, Paul Caponigro, Eadweard Muybridge, George Krause, Walker Evans, and Les Krims all lived in this room. None of them fit neatly into the Catholic hierarchy represented by the cell, none survived the rigors of seminary life which would have resulted in the Jesuit priesthood, and none, of those living, could be lured back to California for the group portrait I wanted to take.

Each furnished the room in slightly different ways: from a large and mysterious Mexican wardrobe inside which, during the weeks prior to his defrocking, George Krause hid his models, to Caponigro's miniature Egyptian sun temple, to Walker Evans's vast and tawdry collection of Day-Glo Last Suppers. Few of these men lasted long and most immediately had second thoughts when confronted by the room.

"I knew it was only a matter of time before I augered out, my celestial F-104 a pile of scrap, my unrepentantly sinful body a burnt offering to the powers that held it in place." — Les Krims, in his autobiography, *Real Life.*

The seminarian whom the older priests thought most capable of going all the way was, of course, Ansel Adams. He quickly established himself as an authority on canon law, was cheerful when others were despondent, and initially took to the priesthood as naturally as a Joe Garagiola selling Dodge trucks. His twin downfalls were women and a series of conversations with Robert Adams, "The Younger," as he was then known. Adams was a brilliant if brooding personality in those days. He forced the proper questions on "The Elder," and his restless mind gave the jolly seminarian no peace. On an ecumenical retreat to Yosemite, he (The Elder) saw the light and with great conviction exchanged his robe for a focusing cloth.

So it went. We know little of the nineteenth-century photographers: Muybridge paced a lot and apparently was very loud, and O'Sullivan hung a sign above his mirror which read, YOU ARE LOOKING AT THE PERSON MOST RESPONSIBLE FOR THE STATE OF YOUR MORTAL SOUL!

It's all no more than a wonderful coincidence, of course. Some shift in the earth — a crack in the universe lined with mother-of-pearl, an intrusive vein of silver in the bedrock of God's high school. Why did these photographers study for the priesthood and why did they all move through this room? I don't know, but the fact that they did seems good.

LUCKY BURGER

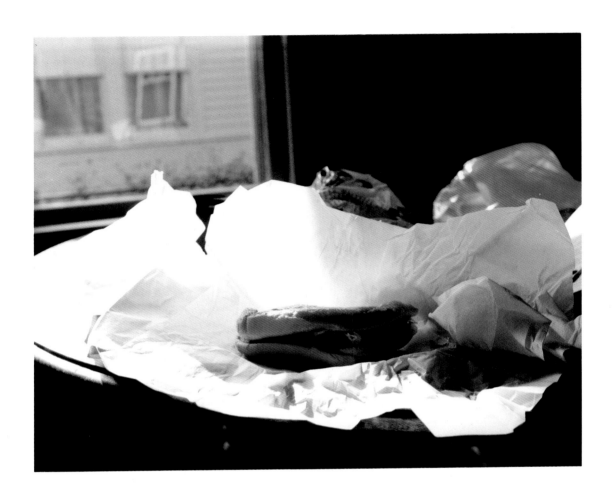

appy Hamburger. It sits like a contented frog, bathed by celestial light in the small but happy pond of fast food heaven. Listen: the burger sings! A happy song of wheat, beef, lettuce, and onions. A song of the heartland, of American virtues, of a contented genericism that renders us brothers and sisters of the road.

Sing, O ye burgers! Sing in a chorus of hunger, satisfaction, and pleasant carnivorousness. Praise ye the wheat fields of Montana, the lettuce lines of Salinas, the feed lots of central Utah, the onion patches of Maui, the tomatoes of southern Oregon, the mayonnaise eggs of Petaluma, and the mustard fields of Wyoming!

Sing a mighty chorus of Americanism! To skies, fries, highways, and trucks. To high winds, high clouds, and the energy of youth. To the whole glorious land. Sing, ye burgers, roar, sing, and believe.

THE KNIGHT'S TALE

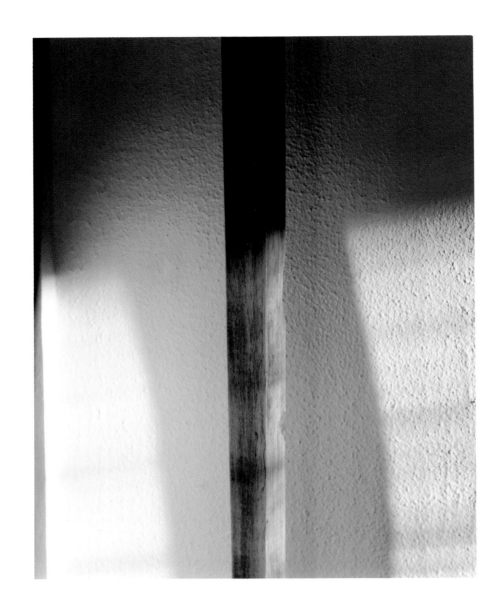

At times I feel that this is the way I would like to live, that this is what I would like to be: clean, strong, and well situated. Colorful yet subdued, confident yet not too bold — a knight, a monk, a lover — even an evanescent presence in sunlight on old wood. But then I think: Who are you kidding?

It's an old debate and the pendulum keeps me coming back for more. As one extreme is understood, its opposite appears mockingly, and I remind myself that the deadly calm of spiritual purity is exactly equivalent to the mind-numbing frazzle of emotional chaos. To cancel one out is to freeze-dry the earth. All this has been proven statistically.

It's the mix, to juggle things even more, it's that high-wire act of riding a trapeze from one circus pole to the other that keeps us loose, that keeps us jitterbugging around in the sawdust like the smart little monkeys we know ourselves to be.

TWO TRUE STORIES

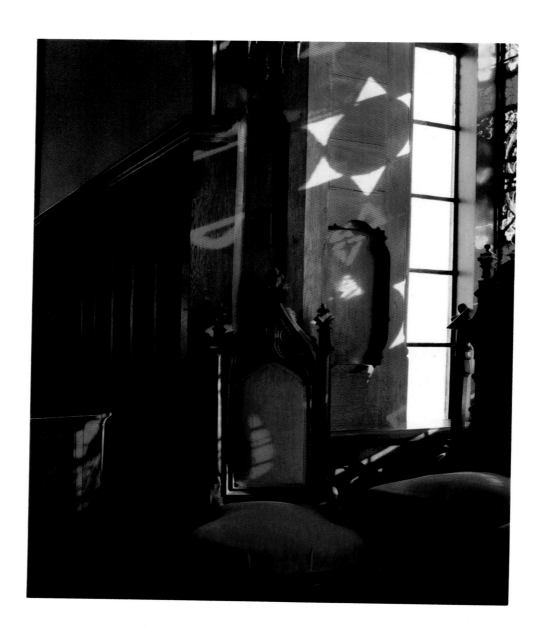

When I was twenty, a friend of mine I greatly admired told me in the cathedral in Tours that she liked the colored light from the stained-glass windows better than the windows themselves.

I was stunned. She was a woman who rarely dropped her guard. She was beautiful, worldly, and two years older than I was. A chance to gain some ground had arrived and I grabbed it. I said that I didn't understand what she was saying — that the rationale for the windows was lost if their content was ignored; that what she was responding to was understandable but of minor importance and that on any chain of aesthetic response it was clear that hers was close to the bottom. As I talked, my eyes were repeatedly drawn to a splash of red, yellow, and blue light on a white stone pillar and I felt like a fool.

The second story concerns my grandfather who, among other things, was a missionary in China, a chemist, and a photographer.

During the looting of Nanking in 1927, troops from the south stormed through the neighborhood of my family's house. My mother, her brothers, and sister were hidden upstairs, my grandmother swallowed her wedding ring, and my grandfather, after welcoming the officers into the house and offering them tea, was pushed up against the living room wall to be shot. The lieutenant in charge took out his rifle and, while in the process of loading it, dropped a bullet to the floor. Without hesitating, my grandfather bent down, picked it up, and handed it back to the man.

The lieutenant was so astonished that he put his gun down, apologized to my grandparents, and ordered his troops out of the house.

"Extraordinary," said my grandfather, reaching for his handkerchief. "Extraordinary."

SPINOFFS: POEMS AND ESSAY
BY DENISE LEVERTOV

It was with some misgivings that I accepted Peter Brown's invitation to write some kind of response to *Seasons of Light*. I very much admired the photographs, and enjoyed the prose pieces that accompany them; would not whatever I could write be superfluous? Yet I felt his request to be both an honor and a challenge; so I acceded to it, though without a clear sense of what I might be able to present.

What happened in the two or three months that followed was — to me — exciting. After looking at all the photographs and reading all the text once, I put the portfolio aside for several weeks. When I began to look at it again, I avoided rereading any of the text or even paying attention to the titles; and, since text and titles are mainly so obliquely related to the visual images, I had no problem "disremembering" them so that I could establish a relationship with the pictures alone. And doing so began to stimulate in me not the prose sentences of an essay, as Peter Brown had requested and I had expected, but poems.

Moreover, these poems were no more directly descriptive of the photographs that triggered them than are Peter Brown's own texts. In fact, the relationship of my poems to the pictures seems virtually identical with that between his own writing and those images: both poems and prose pieces are spinoffs — with the difference that his words spin in part from memories of the actual objects photographed and of the occasion of taking the photo, and mine from encountering the picture itself and discovering within it associations or revelations. What excited me was both the pleasure of that experience in itself — an unforeseen tapping of dormant recognitions, a bouquet of small epiphanies — and the evidence it provided of the peculiar way in which the art of photography can provide that experience for a poet, can act, that is, as a sort of divining rod (or, to switch metaphors, as a springboard) in a manner subtly different from the stimulus of paintings. Of course, I am well aware of the many poems by a wide variety of poets, living and dead, which were inspired by paintings, drawings, prints, or sculpture. Perhaps photographs have been less frequently linked to poems. And I'm certainly not contending that it is somehow better or preferable for poems to derive from photography than from painting. What does interest me is the nature of the words-out-of-visual-image phenomenon, the way in which it differs with the type of visual source. In both cases — words from photo, words from painting — the visual source is an already mediated one, obviously, as distinct from the encounter with the rest of visual experience. In the case of painting, techniques and materials are used which are less common to the nonpractitioner than is the camera; and some years ago (in an essay called "Looking at Photographs") I claimed that it was this that made the difference:

> Even though one may never write a poem directly inspired by a photograph, these
> images drawn from the same sources the poet's own eye can see (photography having,
> even at its most individual, subjective, or transformational, a relationship to the optical

121

far more basic than that of painting) and which are transformed into high art through a medium of unexotic availability, connect at a deep level with the poetic activity; and are, in fact, possible sources — as nature is source — for the poet, to a degree that paintings are not, even to someone who loves them as much as I do. Perhaps another way of saying it would be that photographs — and I don't mean only documentary photographs — teach the poet to see better, or renew his seeing, in ways closer to the *kind* of seeing he needs to do for his own work, than paintings do; while the stimulus of paintings for the poet *as poet*, i.e., their specific value for him aside from his general human enjoyment of them, may have more to do with his compositional gesture-sense (as music may) than with the visualization itself.

I am no longer sure, however, that it is the relative availability of the medium that is crucial; after all, there is as much difference between an Instamatic snapshot and a photographic print by Callahan, Caponigro, or Brown as between applying a fresh coat of paint to your front door and creating "The Birth of Venus"! No, the technical *cause* of the difference is unclear; what is worth pondering is the difference itself. For me — a haunter of museums, mad about painting, a person who has traveled long distances to look at particular works — paintings have not (so far) been a direct stimulus to my own work because — at least, I begin to think this is the reason — they are self-enclosed. They let you *in*, yes; but they don't urge you *out* on a train of subjective associations. Whereas (is it heresy to photographers to say this?) photographs, for whatever reason, do just that. However marvelous the abstract qualities of the composition, however interesting the visual texture, the attitude of the photographer implicit in his or her choice of subject, angle, lighting, and so forth, and however moving the subject documented, a photograph seems to me open-ended.

A survey of poems inspired by paintings might confirm this contrast, for I suspect that the majority would turn out to be either descriptive or reflective, that is to say, relatively objective (even when they celebrate the work) compared with the subjective, associative, unpredictably exploratory ones that potentially, at least, can take off from photos. This is not intended as a value judgment. I am not saying that photographs lack the autonomy, the completeness of paintings; but rather, that it is in the nature of a fully complete photograph to have this quality of open-endedness. If in my own experience I have remained silent about paintings I adore, dismissing any verbal response as presumptuously redundant, it does not imply that I think photographs of the caliber of Peter Brown's unworthy of the same respect as works in other visual media, but that I believe an intrinsic characteristic of his medium to be this potential for eliciting words in the beholder, if that person's own medium is words: verbal constructions that typically neither describe nor comment but move off at a tangent to or parallel with their visual inspiration (in sharp contrast, incidentally, to visual inspirations in Nature,

which one most often seeks to *evoke* visually — a distinctly dissimilar impulse). Peter's own delightful, free-associative writing seems to prove my point. I would even consider advising writers suffering from writer's block to spend an hour a day gazing at a portfolio such as this.

So, what of the poems that follow? As a group, I am calling them *Spinoffs*. As will be seen, the poems have no reference to Peter's texts, but only — in a degree as slant as his — to certain photos. Reading the poems to an audience totally unfamiliar with the visual inspiration, I have found that they seem to "work" on their own, which is, of course, what I had hoped.

I have so far spoken only about the way in which photography can set poems in motion. What is it about Peter Brown's photographs, and certain of them in particular, that I find especially stimulating? When I think of how I might try to describe his style to someone who didn't know it, I find myself looking for a way to suggest the intensity of these pictures: their intense quietness, the intense quietness of objects, the intense quietness of objects in a space, in a place, the sense of a consciousness in what is supposed to be inanimate. . . . Indeed, I at once find myself groping toward a poem. But I would have to talk about colors also — clear, mysterious, and astonishing — and about the presence of the eye behind the camera that has discovered all this beauty in such familiar and sometimes unpromising things. This gift for discovering the miraculous in the ordinary is one to which I always respond strongly, whether it is manifested by writers, by visual artists, or by anyone who joyfully *notices* things one might have missed without their help. Peter Brown certainly has this gift; and with it a strong individuality in what his eye selects in the first place, even before (one feels) that extra perceptiveness makes him discover (and reveal) its extra dimension.

Why I've been impelled to write about some of his pictures and not others is as unanalyzable, I think, as the reasons for his own choices of subject. *Choice* is not really involved anyway; the assumption that it is is one of the fallacies underlying much criticism and biography. One finds the sum of oneself confronting something that speaks (by being whatever it is) and demands a response, not necessarily from that entire sum of one's own thus far evolved identity, but from parts of it at least. And one complies.

Finally, it must be noted that the entire collection is named *Seasons of Light*. In my wish to find out how I reacted to the visual images on their own, without whatever influence Brown's prose and titles might have on my response, I actually managed to forget the overall title too. It was not until I'd written the poems which follow that I remembered it and realized that each poem was essentially, in its under-theme, about light too; subjective, nondescriptive, and only remotely referential though they may seem, I think this testifies to the power of his images. Perhaps all photography can be said to be *about* light, but Peter Brown's photographs are in a special way *tributes* to light. And even poems written *from* them, not *about* them, could not fail in some way to share their impulse.

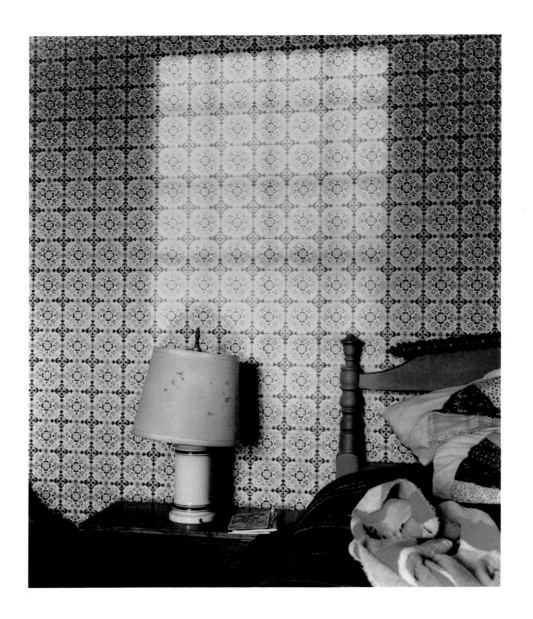

A DOORKEY FOR CORDOVA

. . . And light made of itself an amber
transparency one sundown, restoring
Moorish atavistic imprints almost
to memory, patterns tight-closed
eyes used to make in childhood when
the greenish thickwoven cotton tablecover,
frayed and become an ironing sheet, linked itself somehow
to a Septembery casbah imagined
before any casbah became knowledge. . .

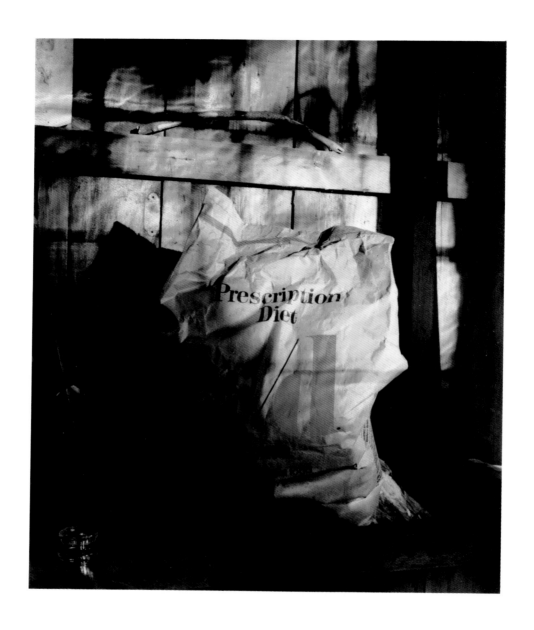

ATHANOR

Tempered wood. Wrought light. Carved
rags. Curdled gold, the thin
sheets of it. The leaves of it.
The wet essence of it infused.
Effluvia of gold suffused throughout. The saturation.
The drying. The flaking. The absorption.
It is a paper sack, a paper sack for dogfood, dry,
the dry wafers of a sacrament, a sacred sack,
its brownish pallor illumined, inscribed with red,
upheld by a manylayered substance
plush as moss, chocolate-dark, dense, which is shadow,
and backed by a tentative, a tremulous
evanescence which is wood
or which is the tardy sungleam from under cloudbank
just before evening settles,
that percolates through cobwebs and thick glass.
Which is the fleeting conjugation
of wood and light, embrace that leaves wood
dizzy and insubstantial, and leaves light
awestruck again at its own destiny.

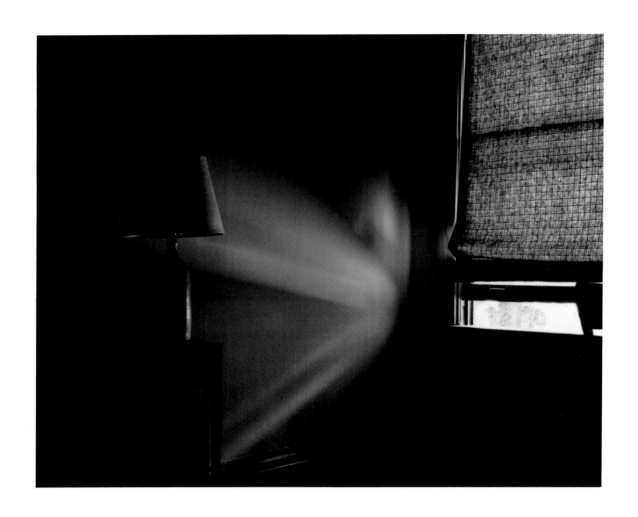

WINDOW-BLIND

Much happens when we're not there.
Many trees, not only that famous one, over and over,
fall in the forest. We don't see, but something sees,
or someone, a different kind of someone,
a different molecular model, or entities
not made of molecules anyway; or nothing, no one:
but something has taken place, taken space, been present, absent,
returned. Much moves in and out of open windows
when our attention is somewhere else,
just as our souls move in and out of our bodies sometimes.
Everyone used to know this,
but for a hundred years or more
we've been losing our memories, moulting, shedding,
like animals or plants that are not well.
Things happen·anyway,
whether we are aware or whether
the garage door comes down by remote control over our
recognitions, shuts off, cuts off — .
We are animals and plants that are not well.
We are not well but while we look away,
on the other side of that guillotine or through
the crack of day disdainfully left open below the blind
a very strong luminous arm reaches in,
or from an unsuspected place, in the room with us,
where it was calmly waiting, reaches outward.
And though it may have nothing at all to do with us,
and though we can't fathom its designs,
nevertheless our condition thereby changes:
cells shift, a rustling barely audible as of tarlatan
flickers through closed books, one or two leaves
fall, and when we read them we can perceive,
if we are truthful, that we were not dreaming,
not dreaming but once more witnessing.

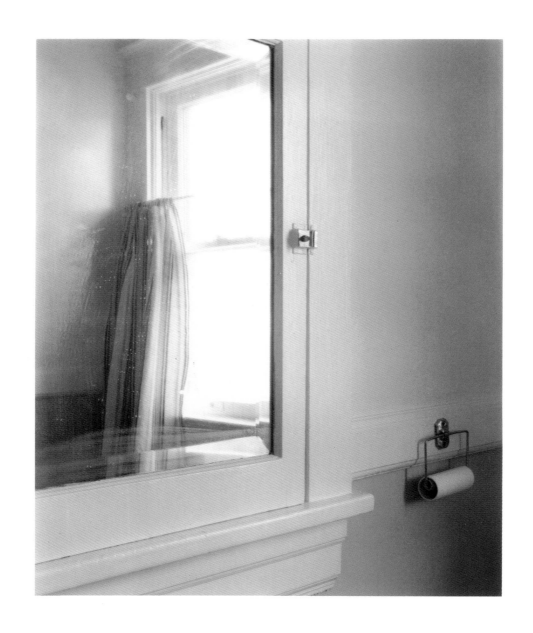

THE SPY

Everything was very delicately striped.
You could see the wood-pulse exquisitely throb
under paint's thin tissue, beside
the mirror limpid in its film
of silver,
most justly beveled,
most faintly steam-blurred,
most faintly warped as if with just sufficient
bruise to tinge
with tenderness its icy patience.
A few sheets of paper were still on the roll;
the austere and efficient holder cast, in the shadows,
a sprightly fantasy of itself in stronger shadow, crossing
the beveled molding. This the glass
never could reflect,
never unless the entire closet door, wrenched from its hinges,
were placed across the room and
forced to look back,
or a second mirror
brought in to face it: neither of them
with a word to say.
There was blue, there was brown paler than ivory, a half-curtain,
there were other blues and an aspiration to whiteness,
there were preludes to green, pink, gold and aluminum,
mostly there was the sense that though
the light would fade
and return next day and slowly move
from right to left and again
fade and return, yet
the stillness here, so delicate,
pulse unquickened, could outwait
every move.

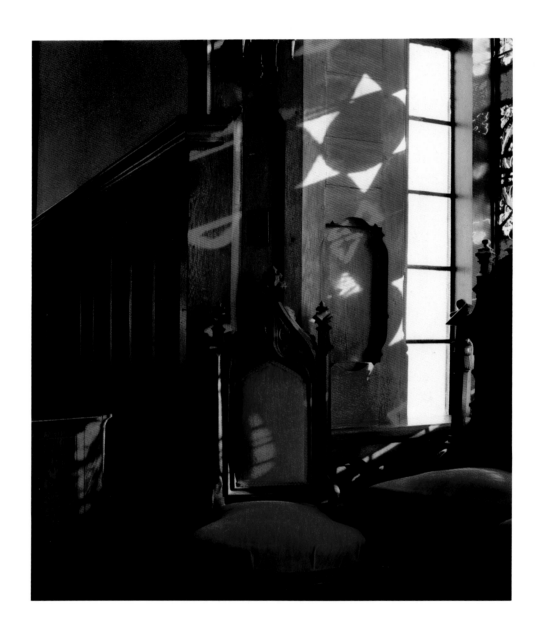

EMBRASURE

The wind behind the window moves the leaves.

James with his cockleshell or Genevieve
a fraction westward move each day
in ruby beads,

a rosary let fall (*with lily, germander, and sops-in-wine*)
decade by decade through the year
across the wall, along the floor.

The figures ripple and the colors quicken.
In cloud or dark invisible
yet moving always, and in light

turning — the circle
east by west or west by east
day after day

constant in pilgrimage. The wind
behind the window moves
the leaves, the bare

branches stir or hold
their breath, their buds,
up to remotest stars.

And dustmote congregations file
endlessly through the slanted amethyst.